FLOWER FASHION
FANTASIES
COLORING BOOK

MING-JU SUN

DOVER PUBLICATIONS, INC.
MINEOLA, NEW YORK

Note

On display in the thirty-one images in this charming coloring book are glamorous gowns and equally appealing accessories, modeled by an array of delicately featured models. The gowns themselves represent a wide range of floral fashions with motifs from Japanese, Chinese, and Indian art, as well as botanical sources. Enjoy the intricacies of these designs as you color the distinctive illustrations.

Bibliographical Note

Flower Fashion Fantasies Coloring Book is a new work, first published by
Dover Publications, Inc., in 2012.

International Standard Book Number

ISBN-13: 978-0-486-49863-8
ISBN-10: 0-486-49863-8

Manufactured in the United States by RR Donnelley
49863814 2016
www.doverpublications.com

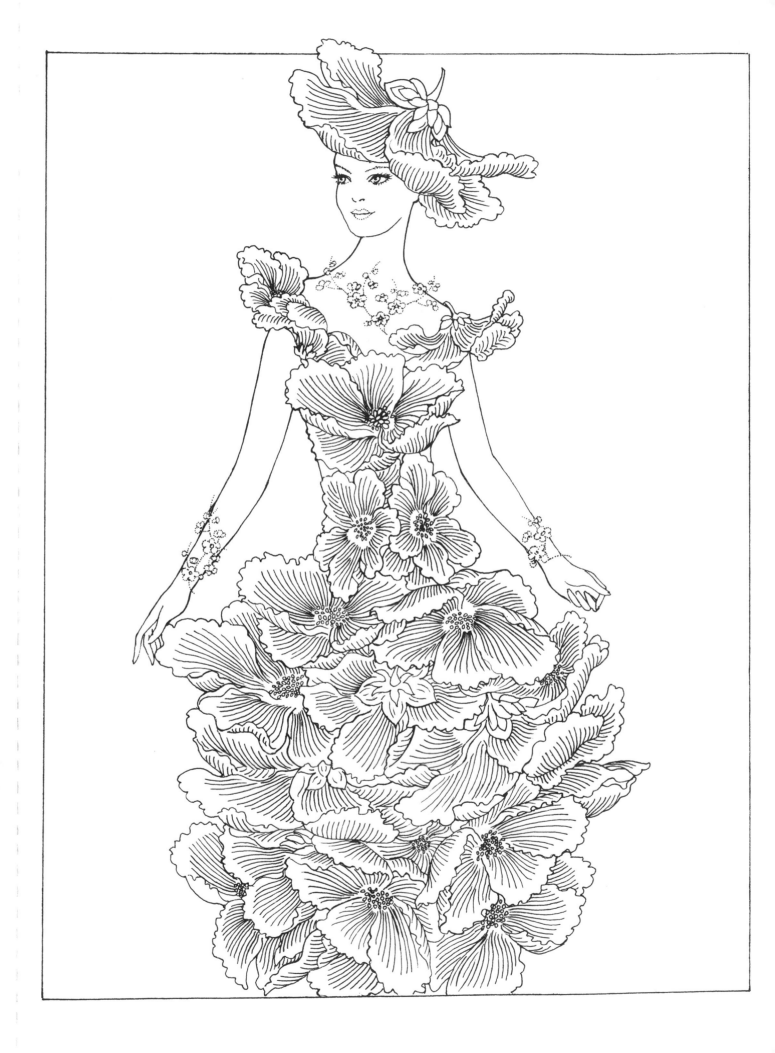

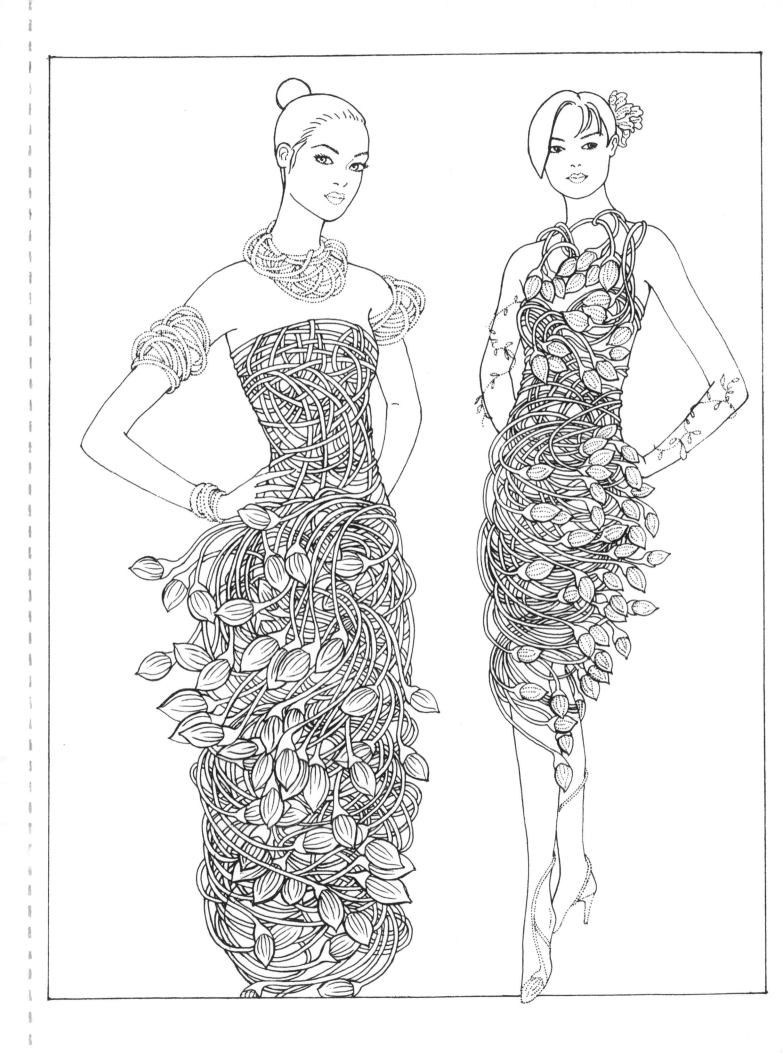

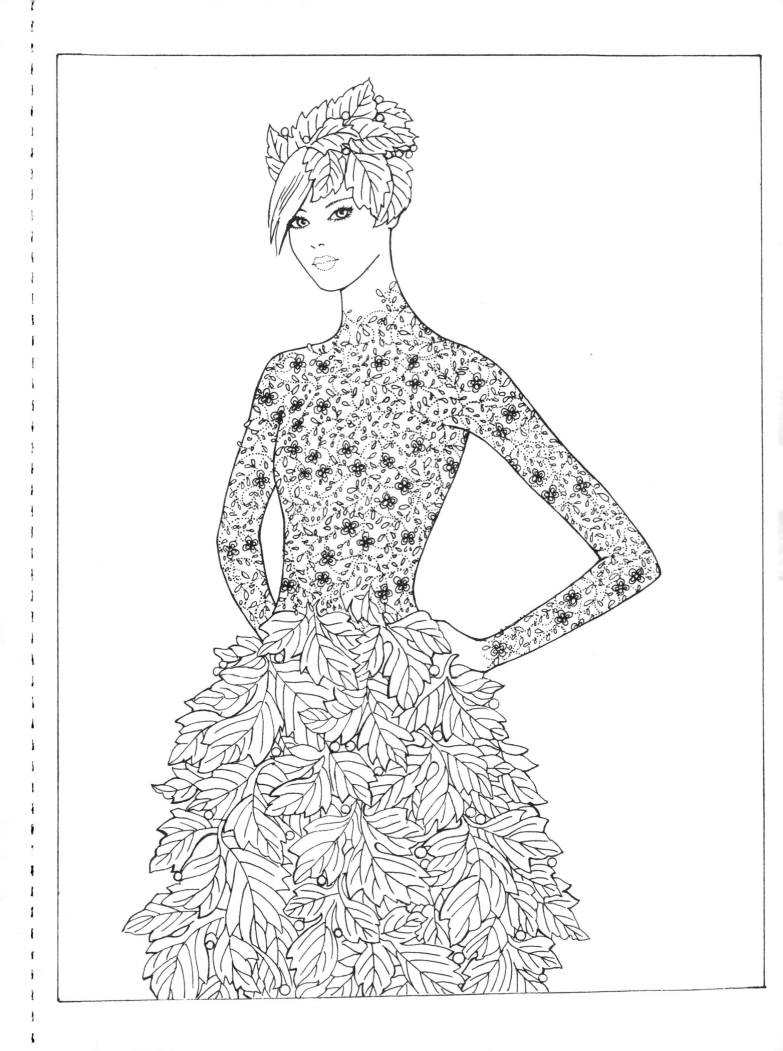

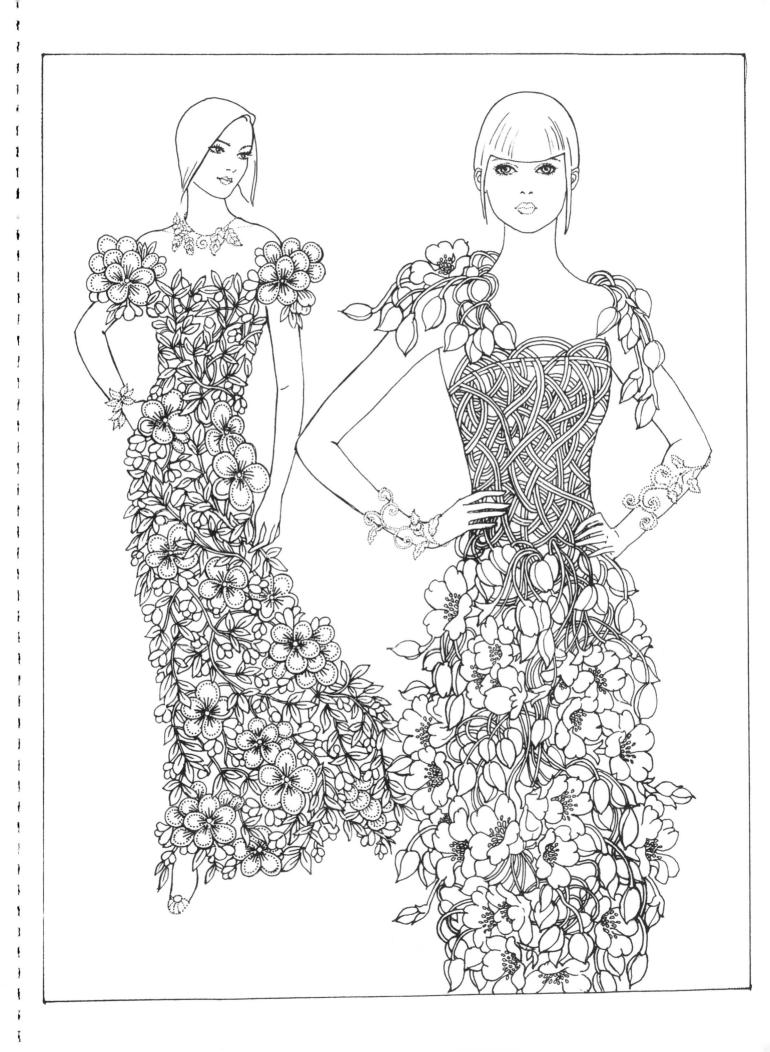

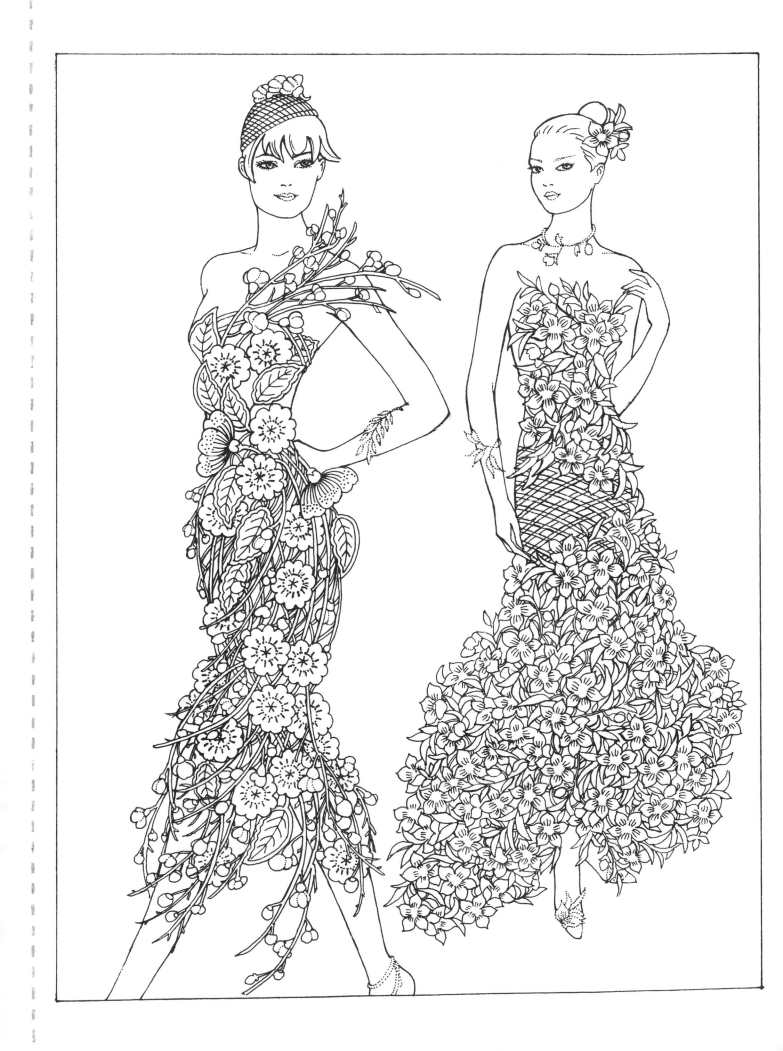

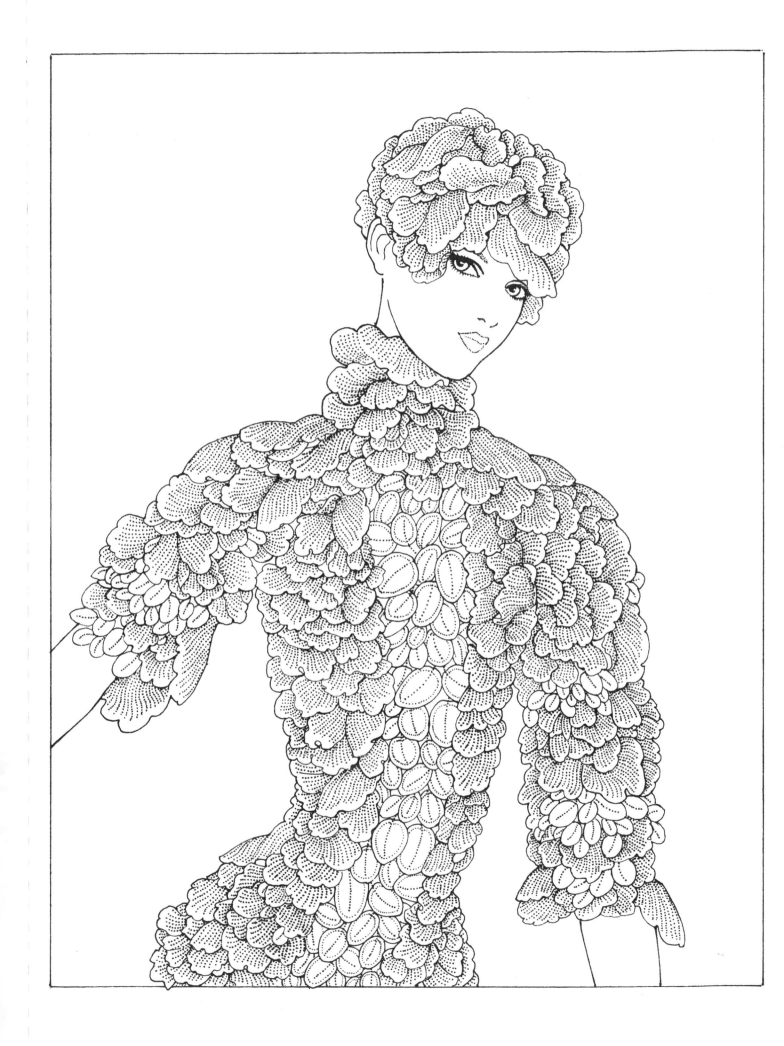

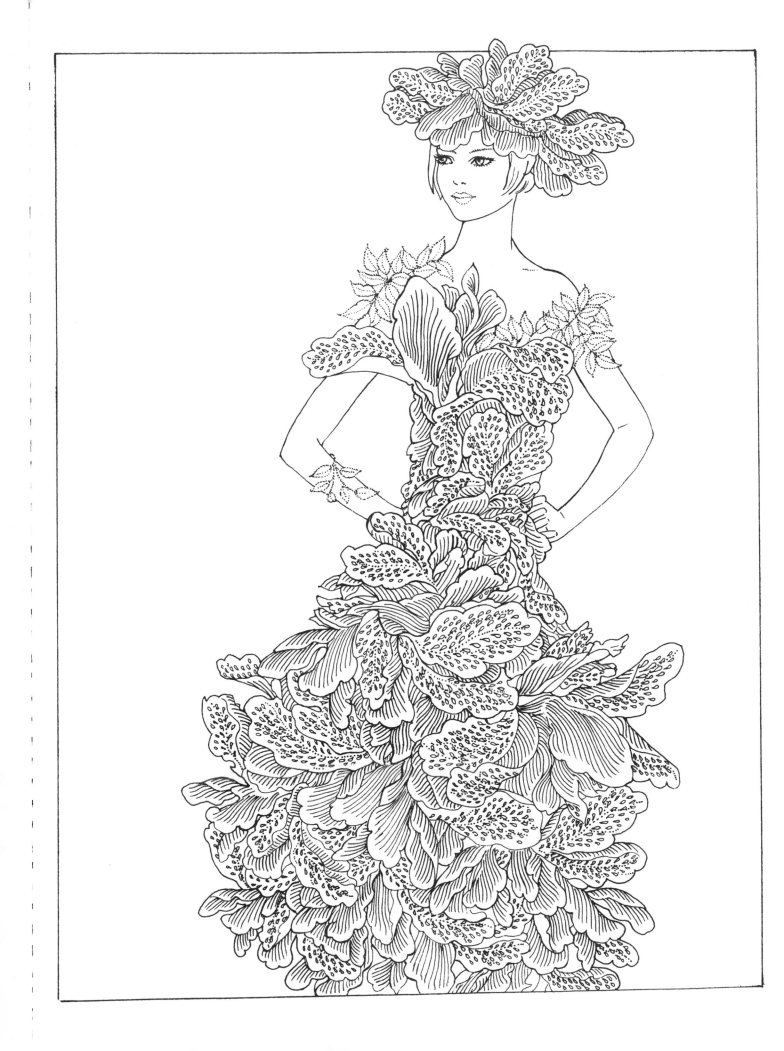

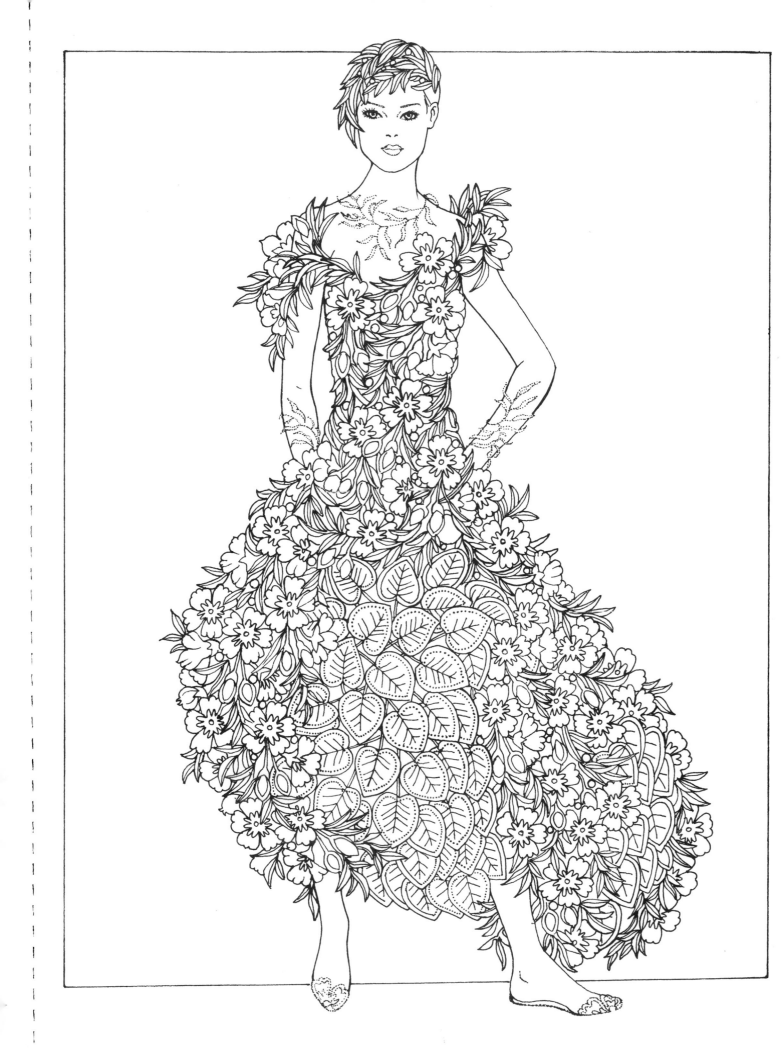

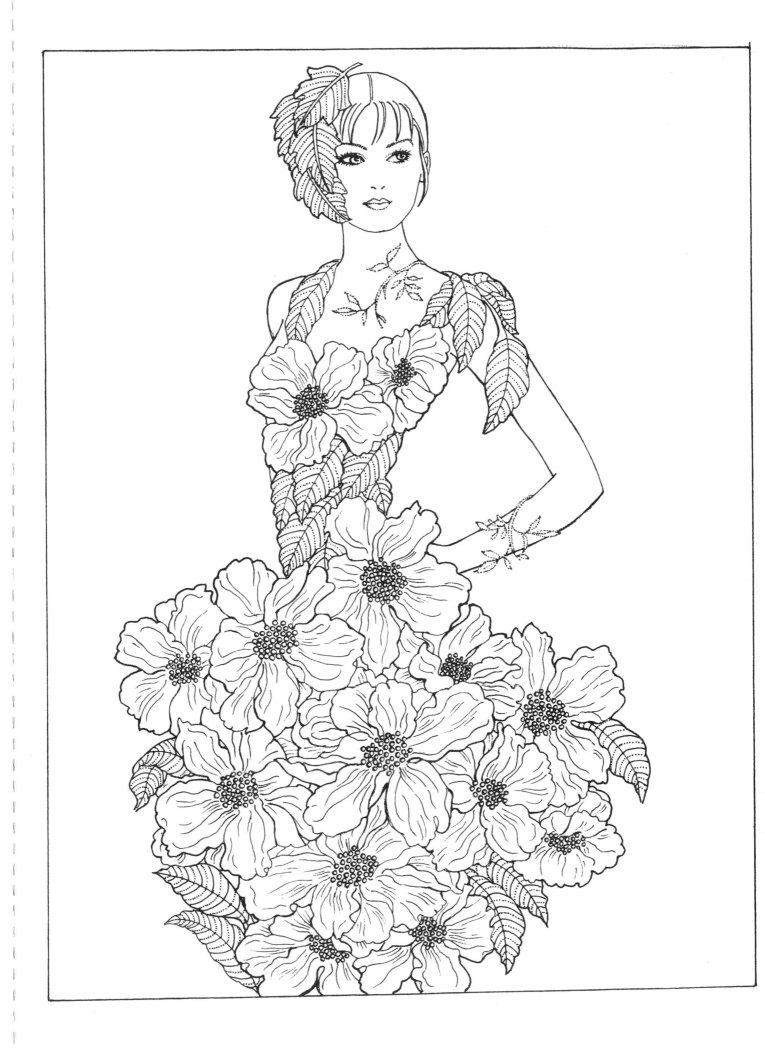

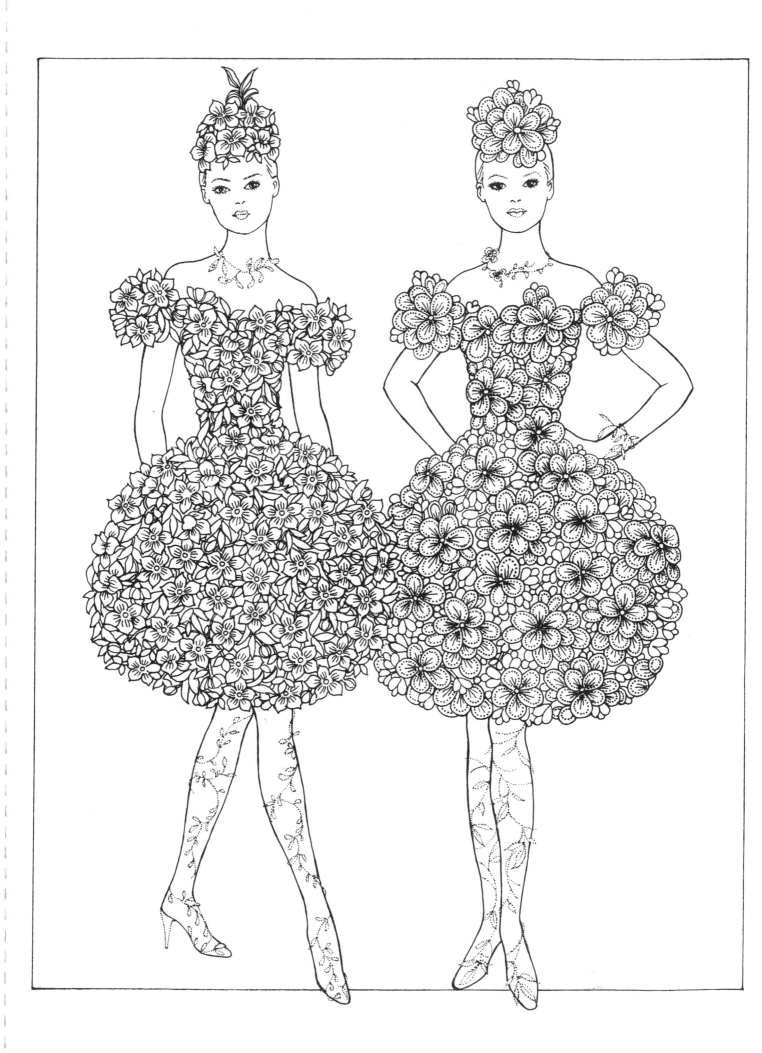

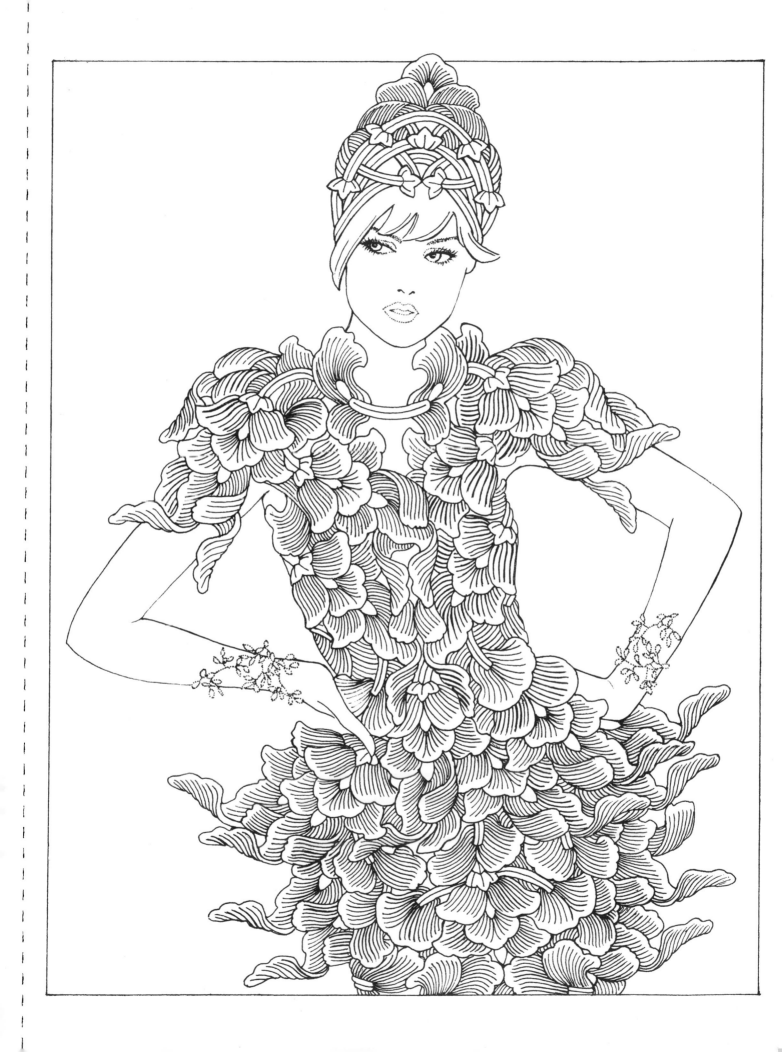

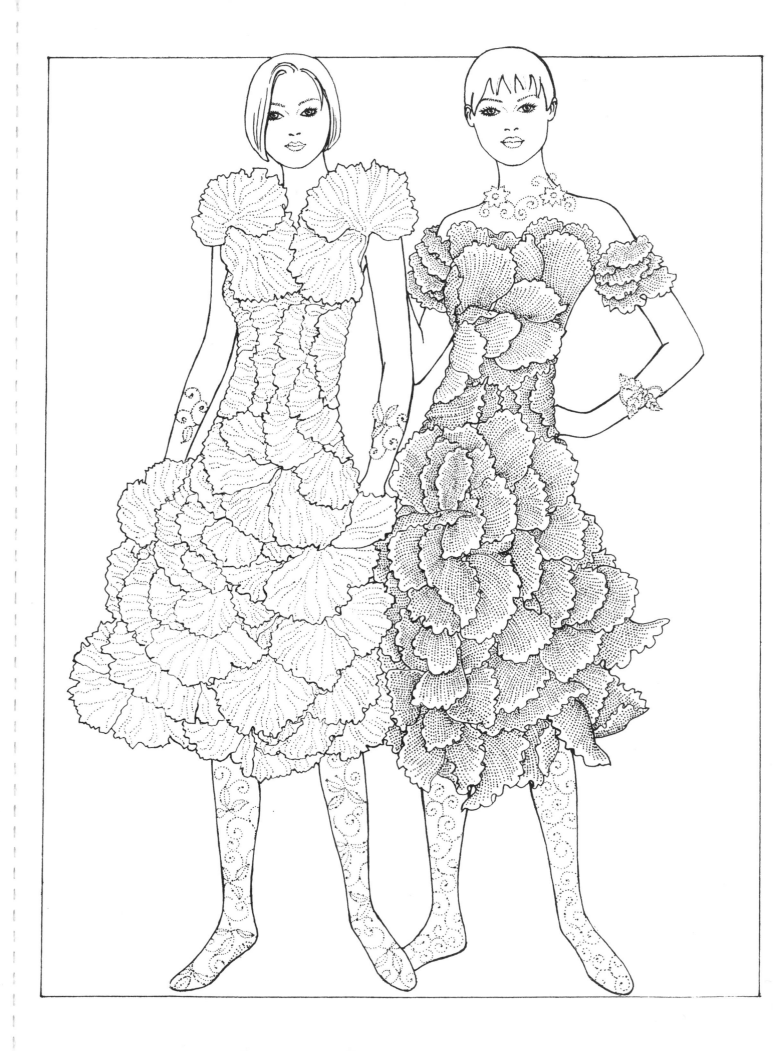

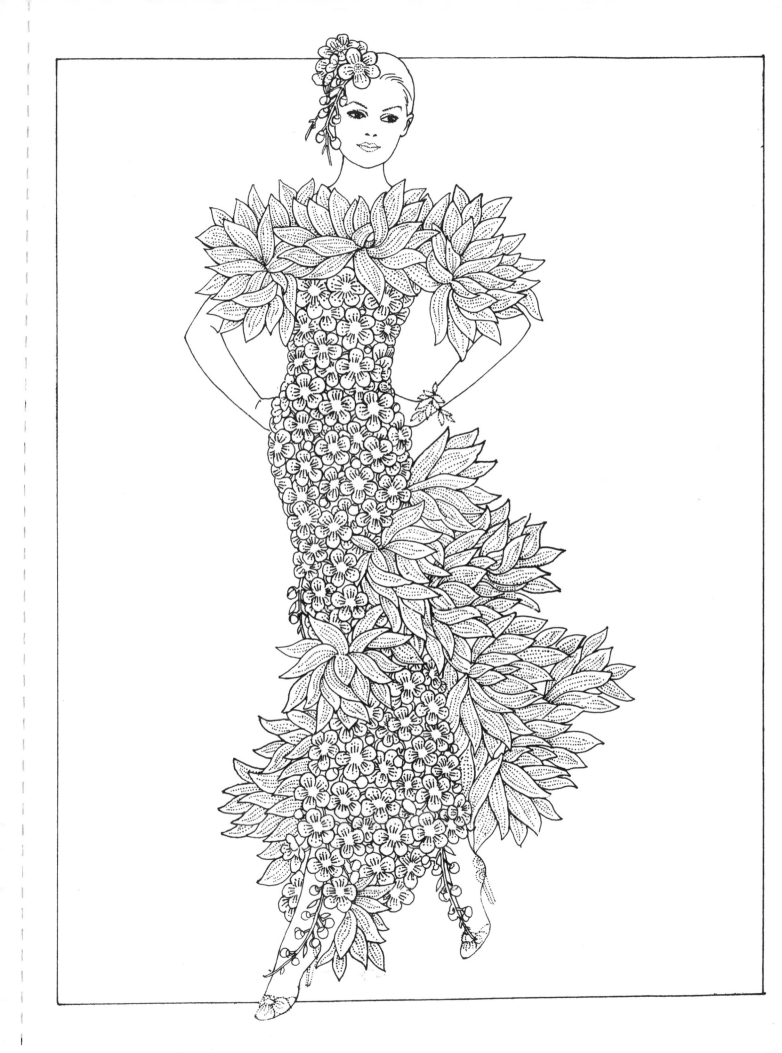

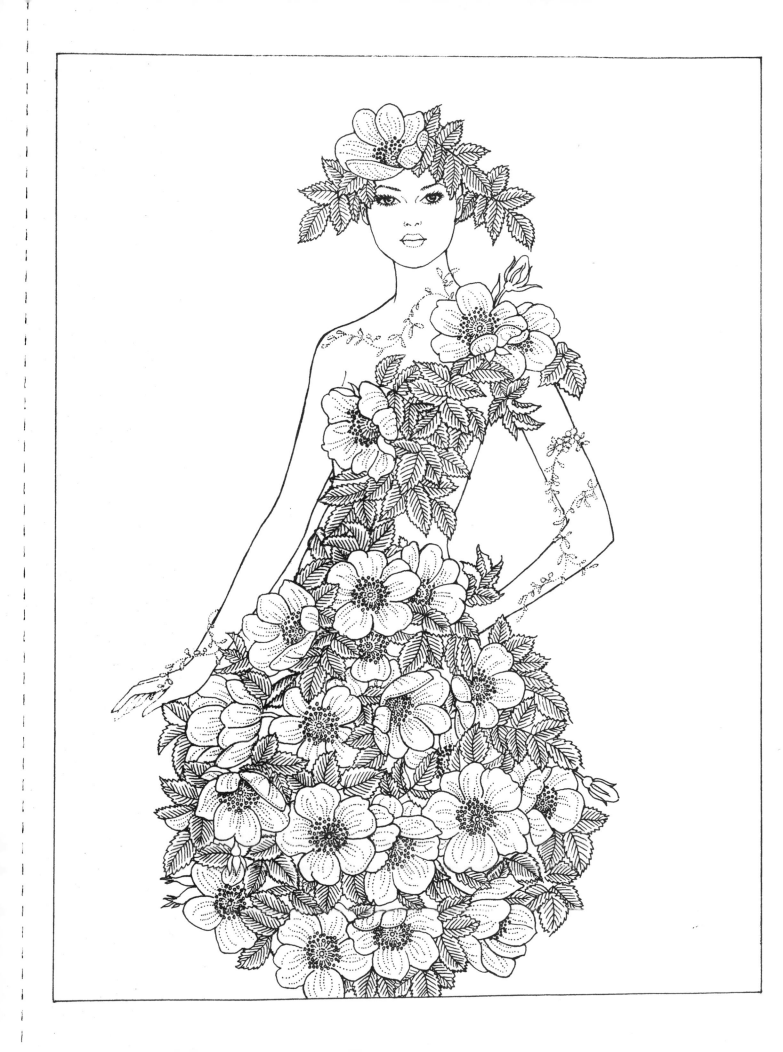

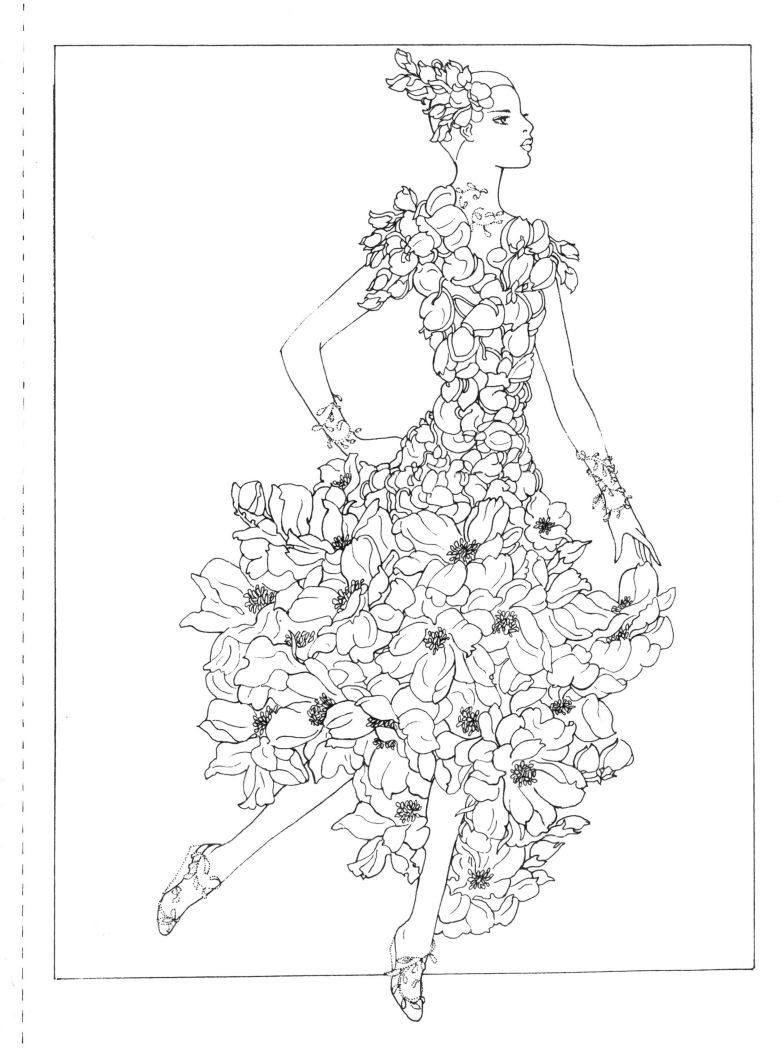

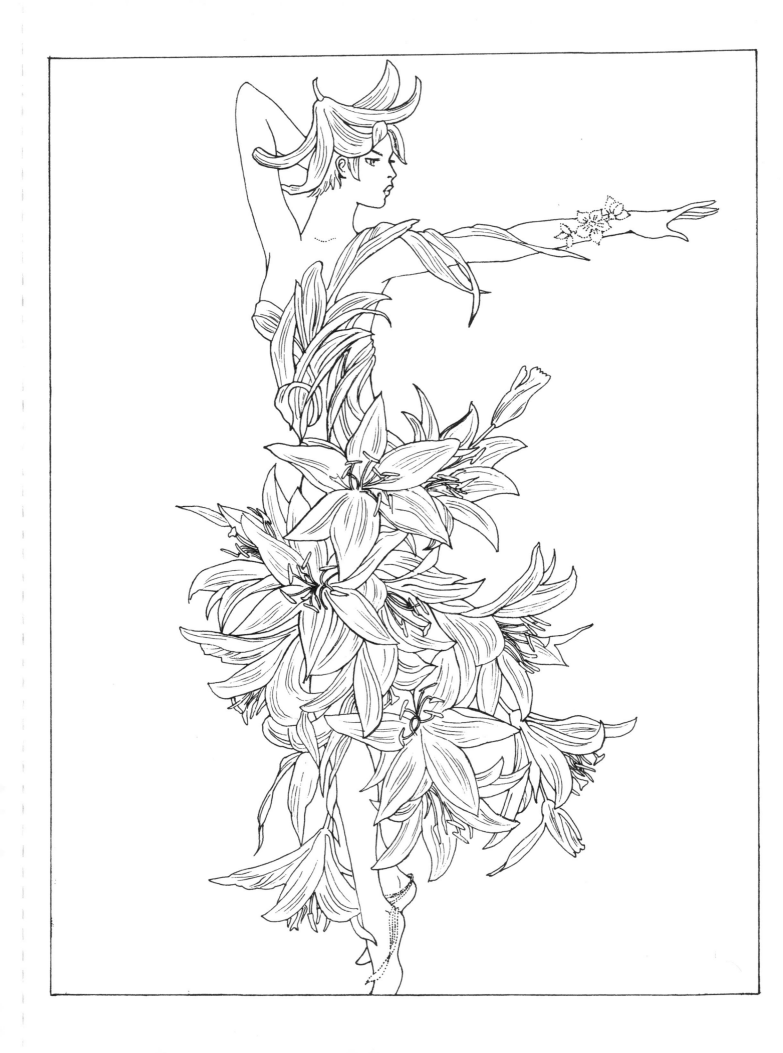

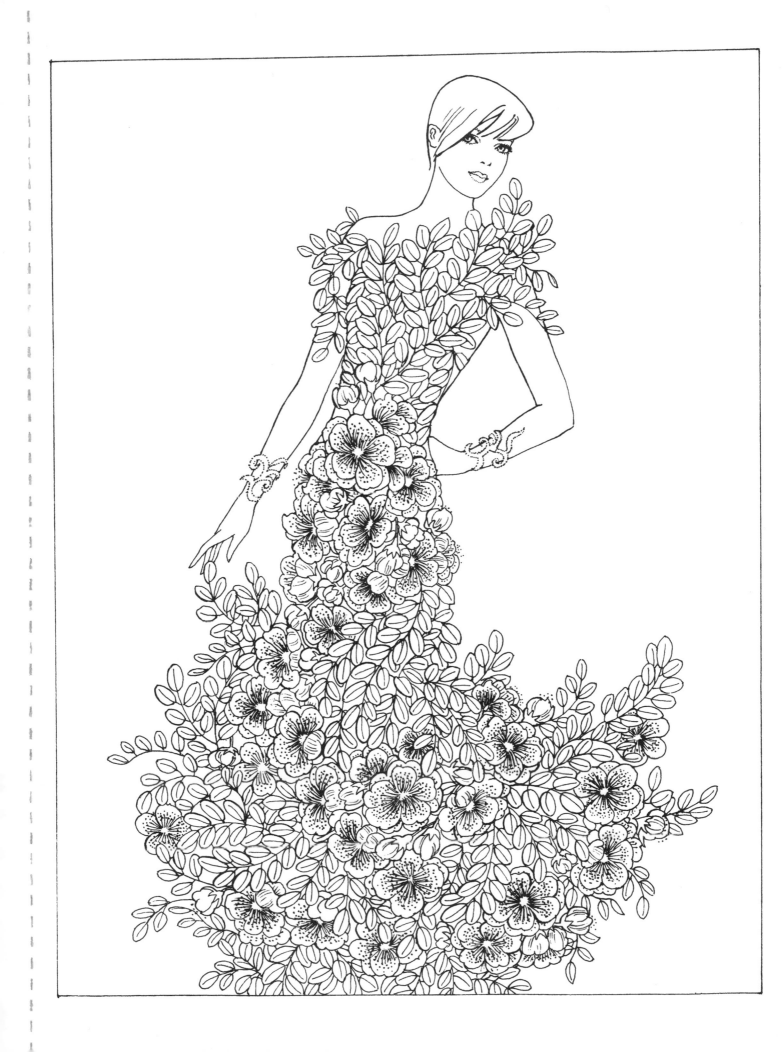

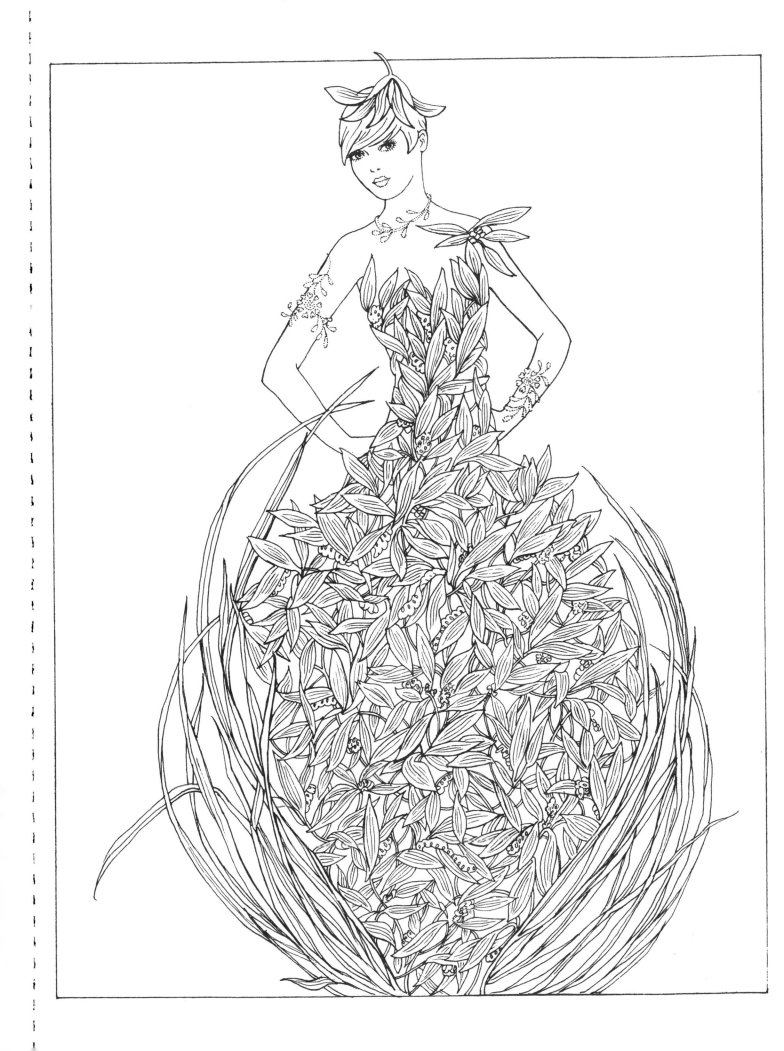

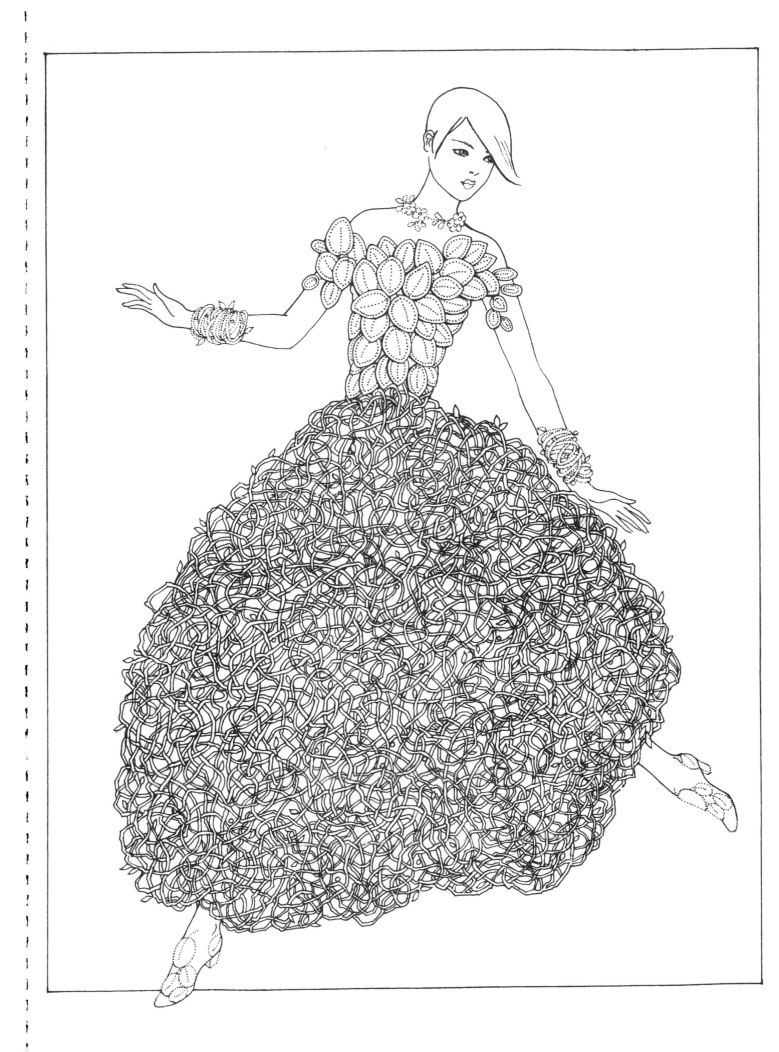

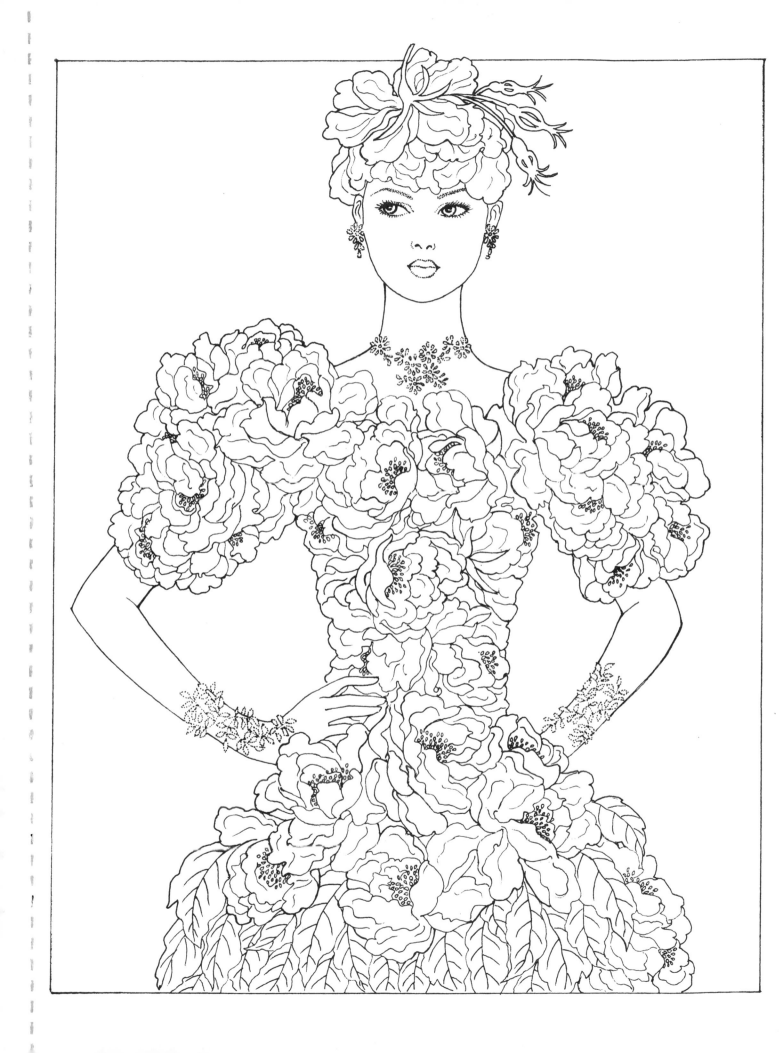

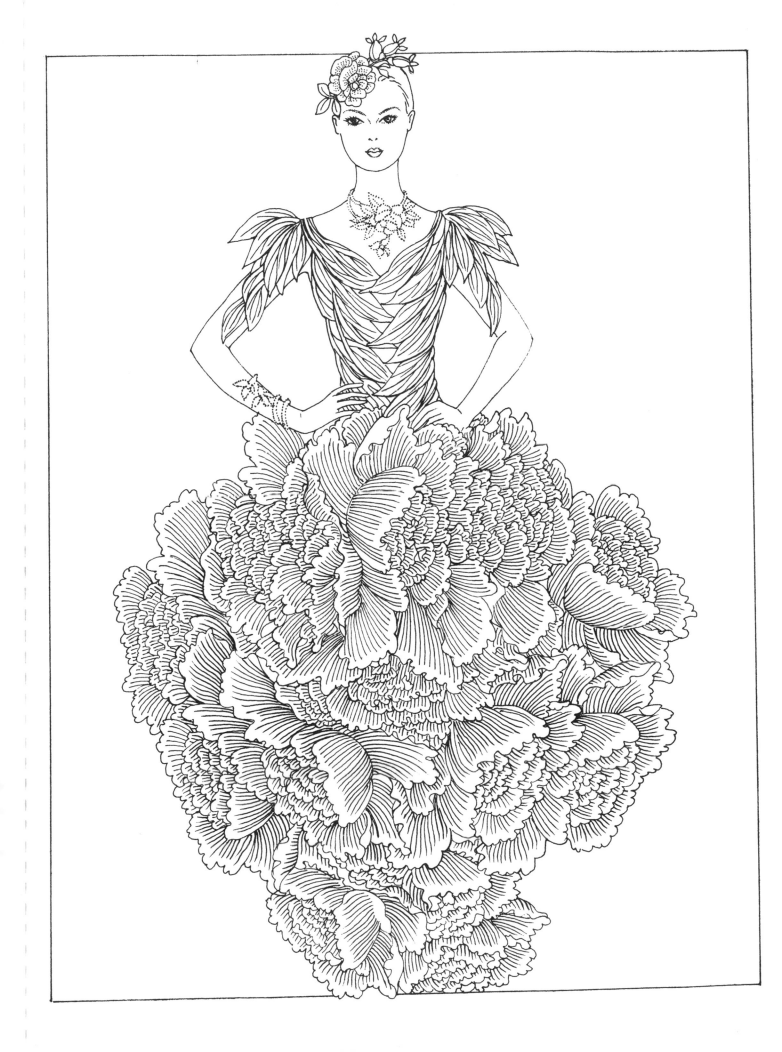

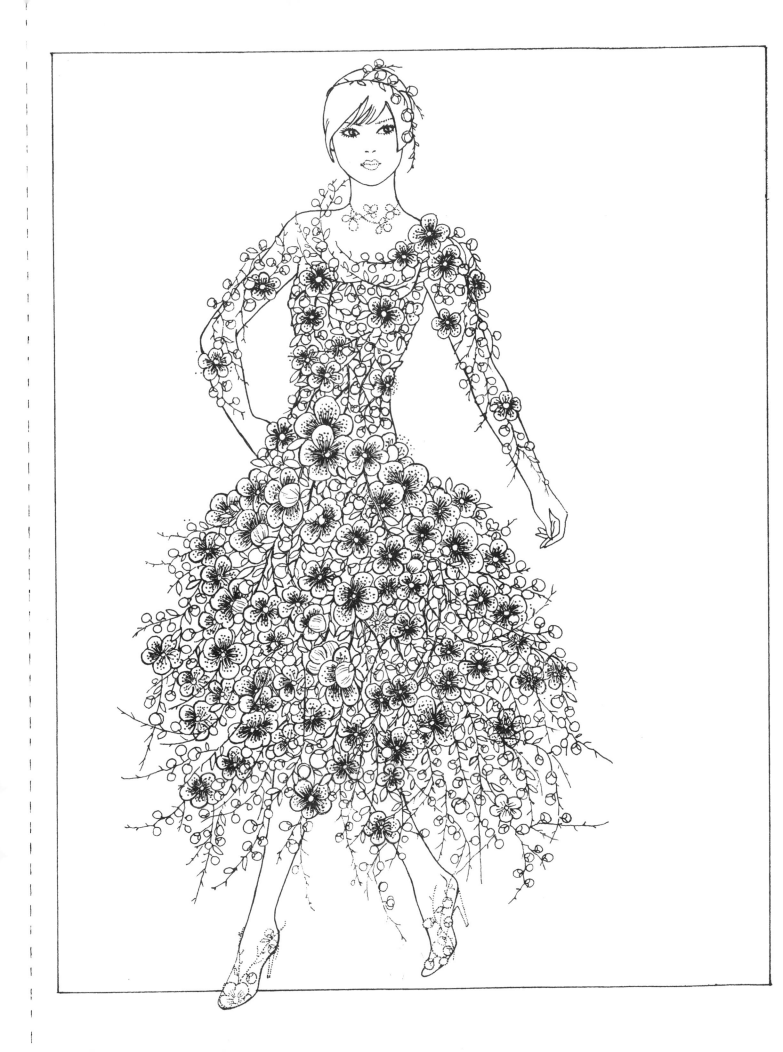

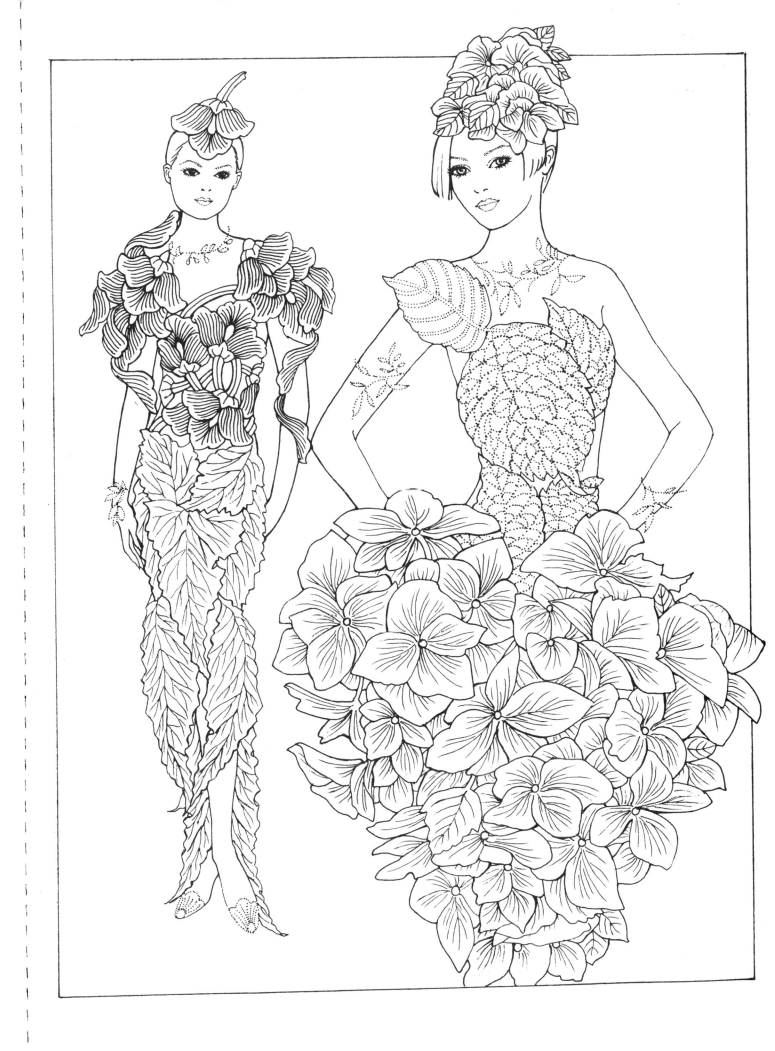

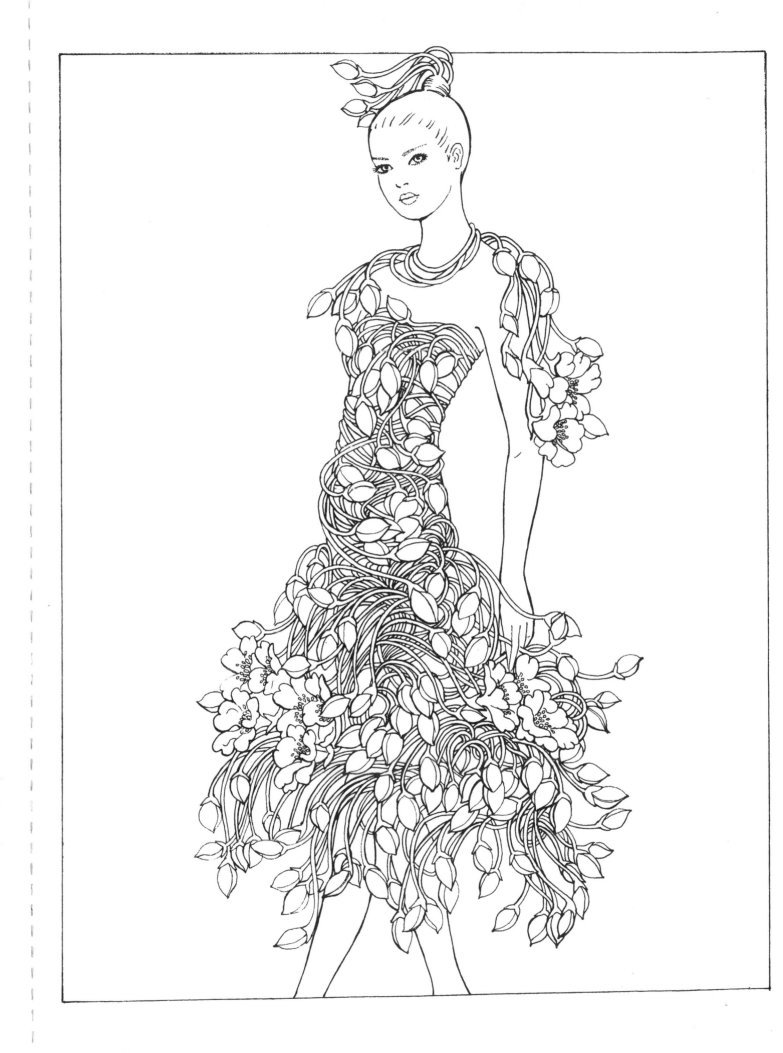

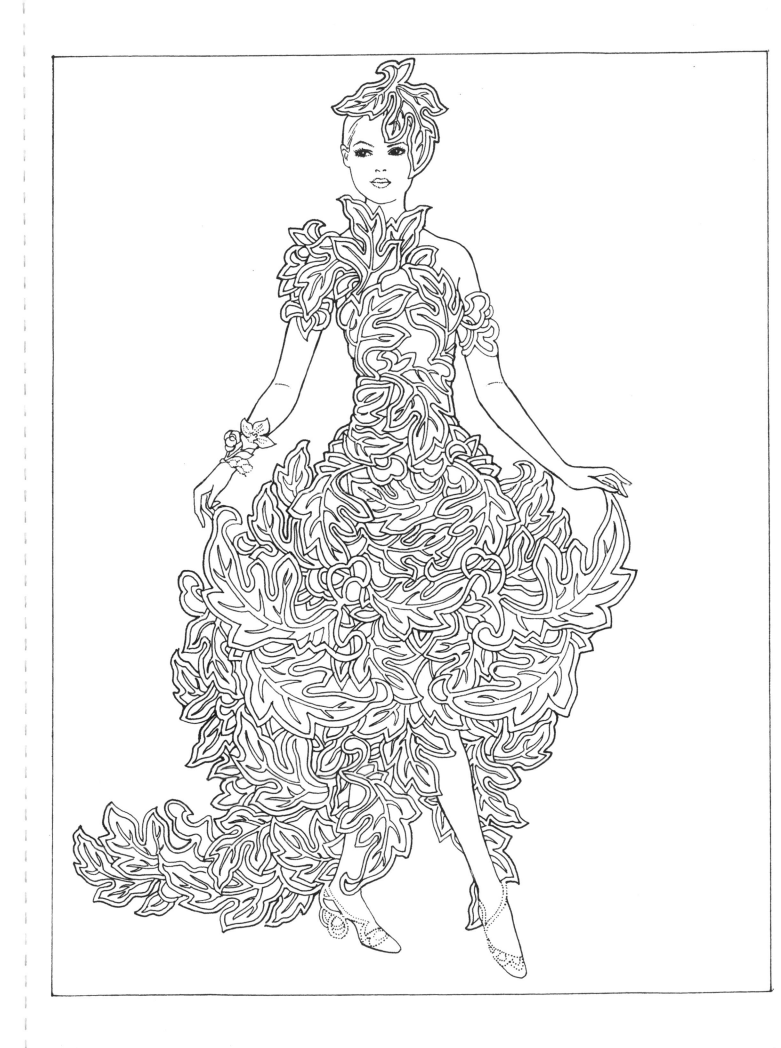

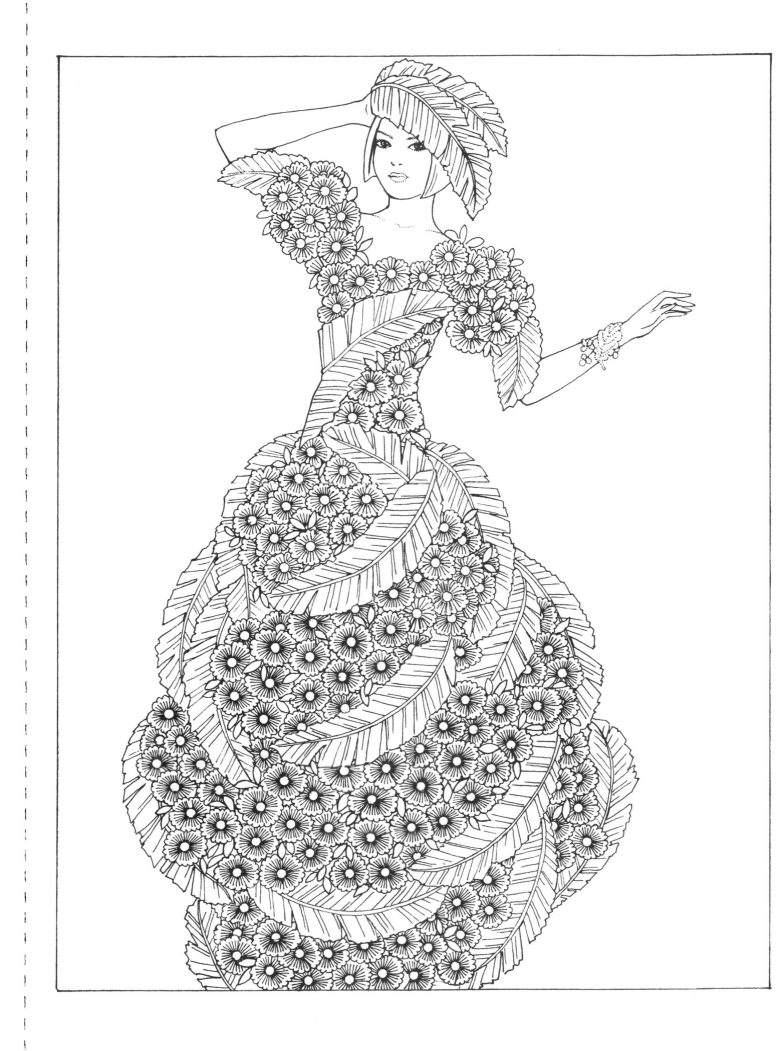

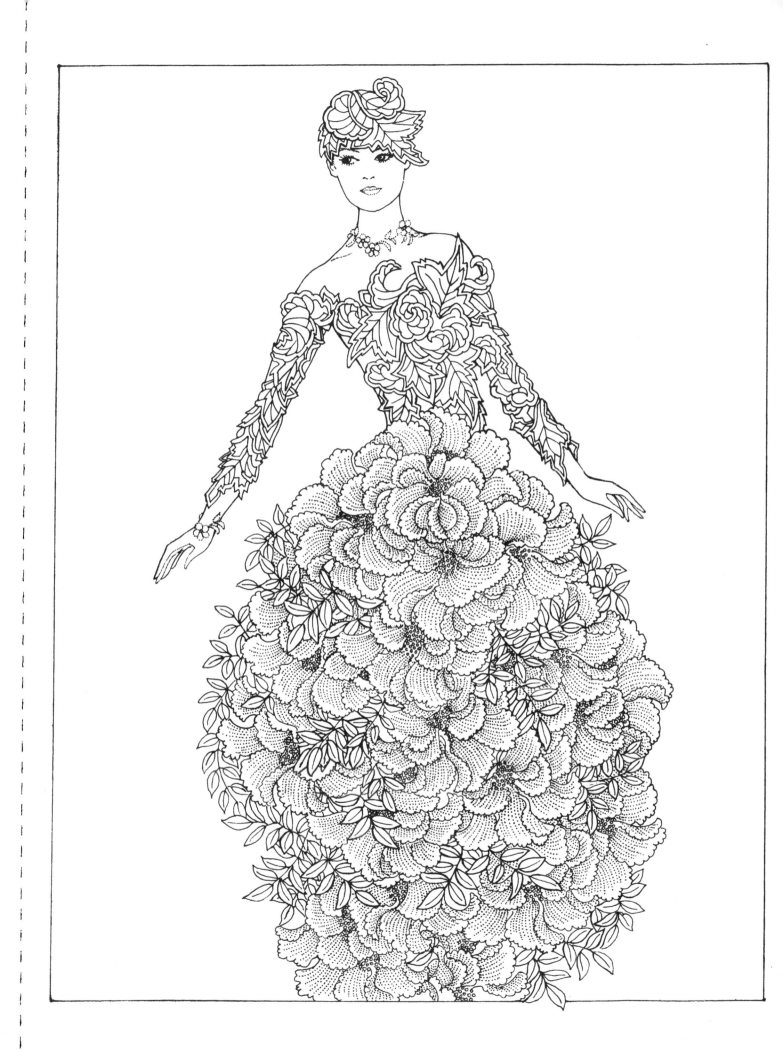

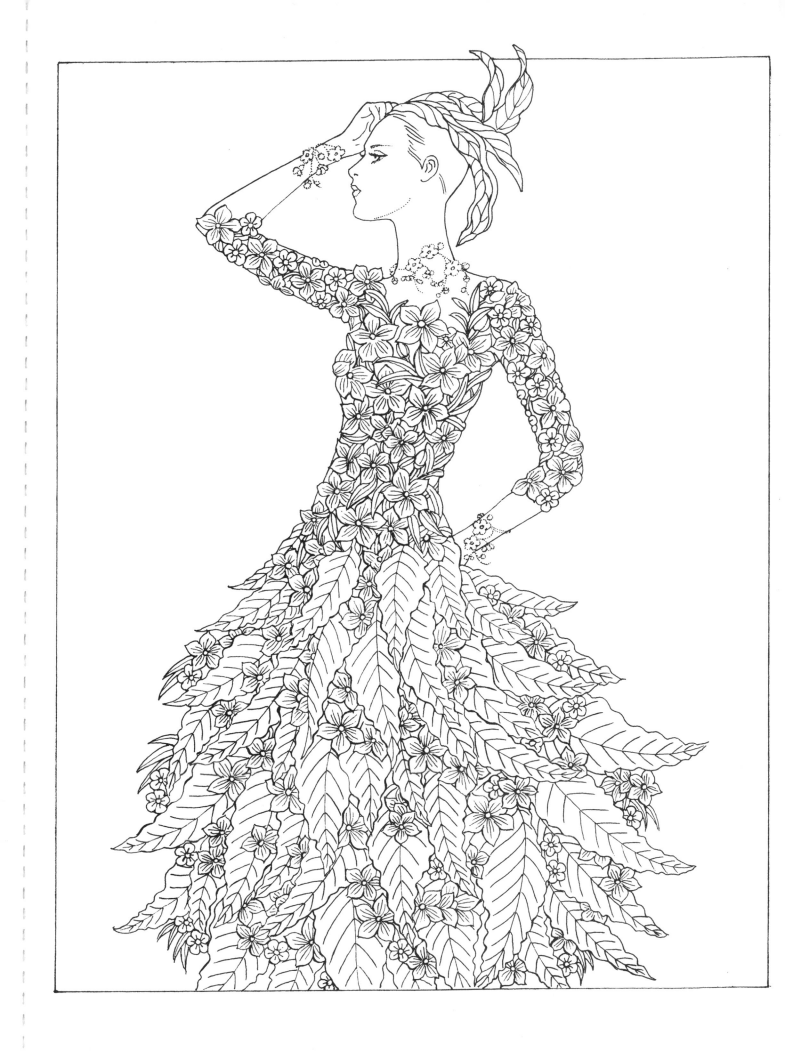

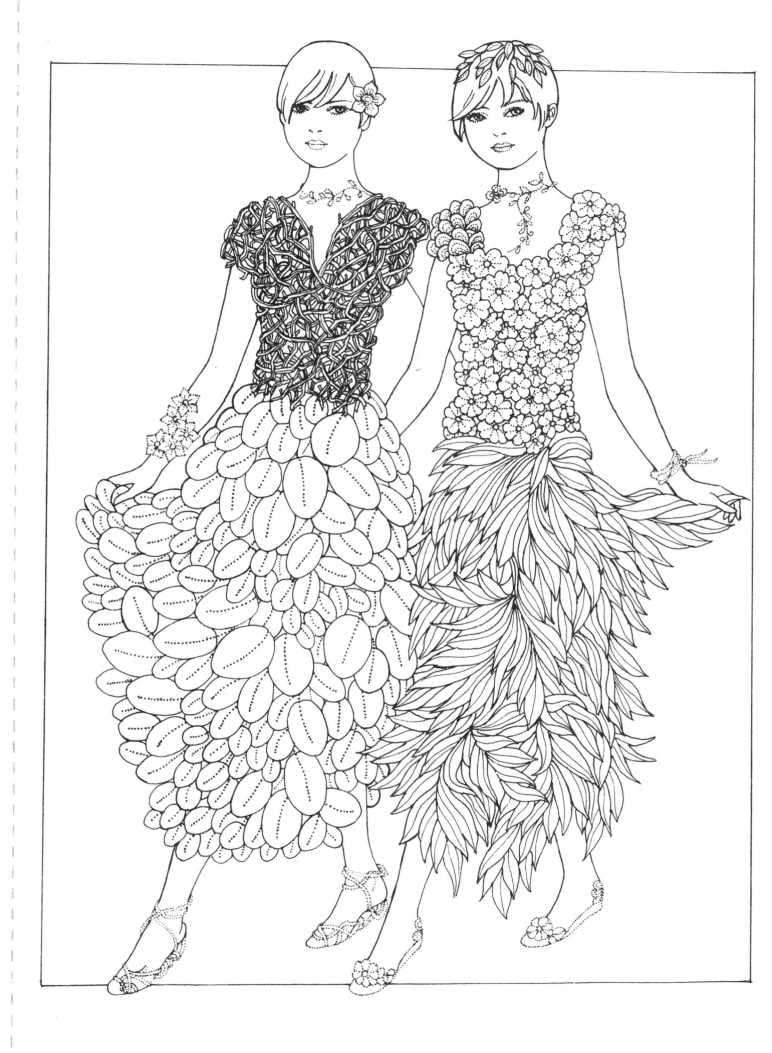

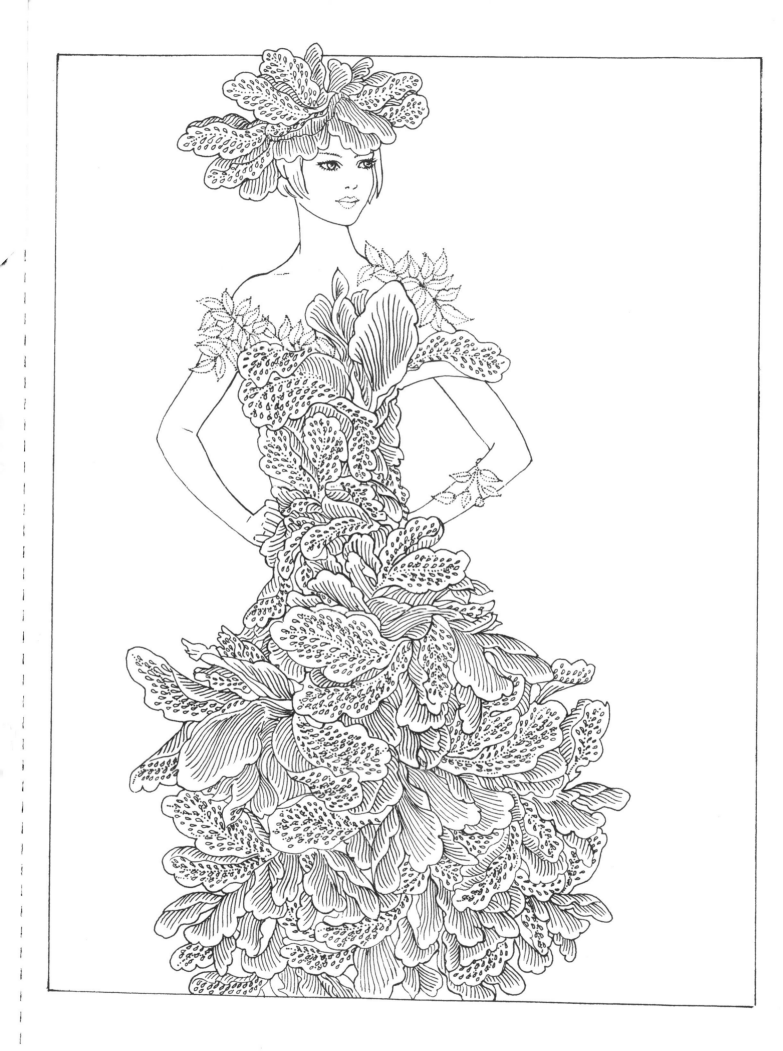